101
Uses
for a
CAT

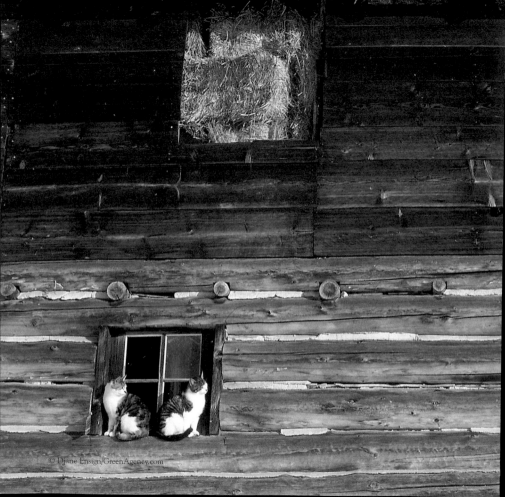

101 Uses
for a
CAT

Edited by Andrea Donner

Willow Creek®
P R E S S

101 Uses for a Cat
Edited by Andrea Donner

Published by Willow Creek Press
P.O. Box 147 • Minocqua, Wisconsin 54548

For information on other Willow Creek titles, call 1-800-850-9453

Design: Pat Linder

Library of Congress Cataloging-in-Publication Data

101 uses for a cat / edited by Andrea Donner.
 p. cm.
 ISBN 1-57223-575-6 (hardcover : alk. paper)
 1. Cats--pictorial works. 2. Photography of cats. I. Title:
One hundred one uses for a cat. II. Title: One hundred and one
uses for a cat. III. Donner, Andrea K.
 SF446 .A155 2002
 636.8'0022'2--dc21
 2002001085

Printed in Canada

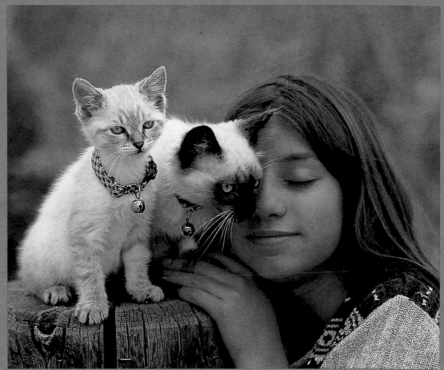

Cats as companions…

Someone to come home to

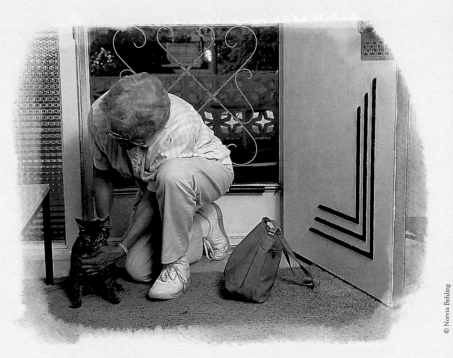

2

Someone to read bedtime stories to

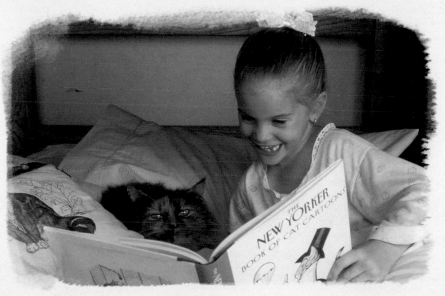

3 Someone to picnic with

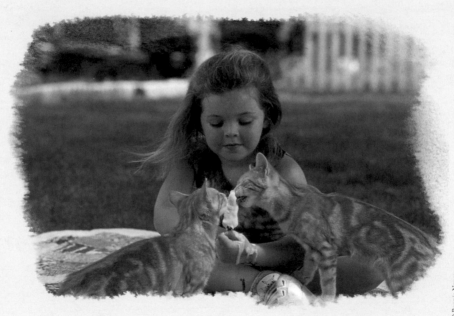

© Bonnie Nance

4 *Surrogate sister*

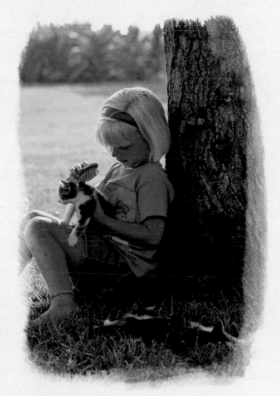

5 *Hand warmer*

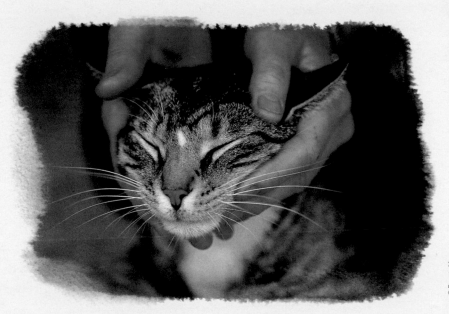

© Bonnie Nance

6 *Foot warmer*

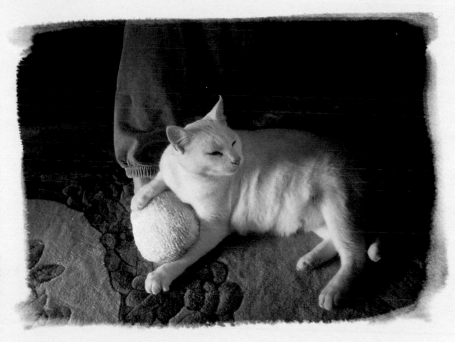

7

Shoulder warmer

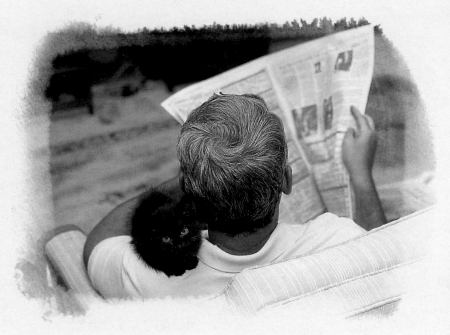

8

Hug for the asking

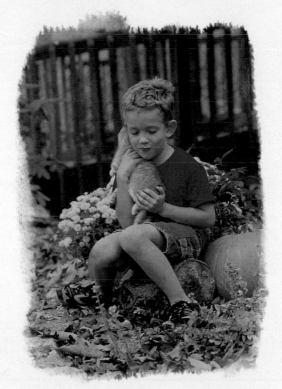

9 *Patient*

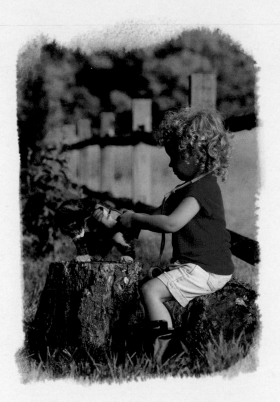

10 Conversation piece

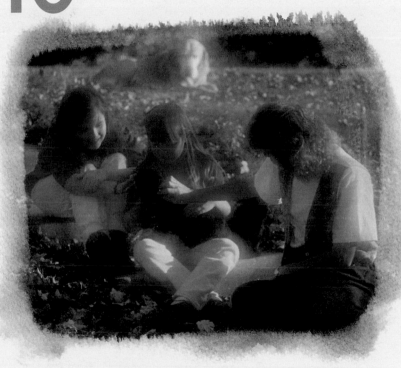

Pocket pal

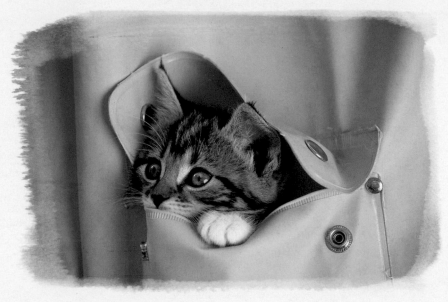

© Sharon Eide / Elizabeth Flynn

12 *Lap-top*

13 *Fellow traveler*

14 *Seat saver*

15 *Someone to study with …*

16 *...or play hooky with*

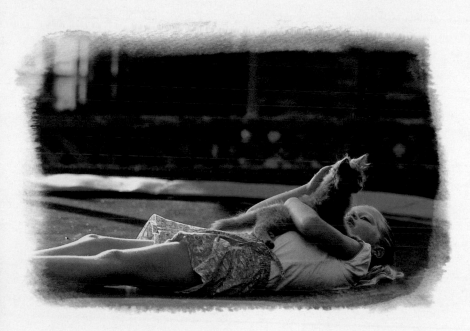

17

Someone to lift your spirits . . .

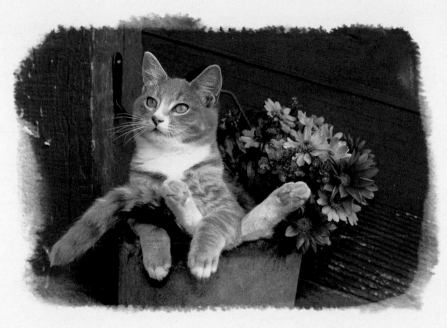

18 *and share your hobbies*

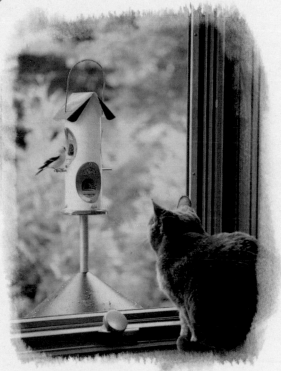

19 Cargo

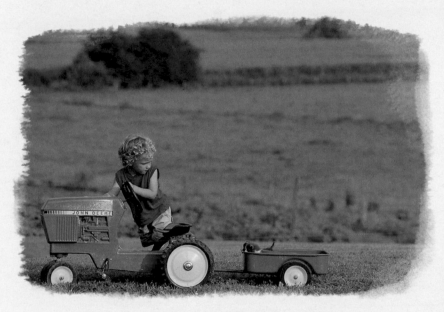

© Bonnie Nance

20 *Hide-and-seek partner*

21

Someone to share your lunch…

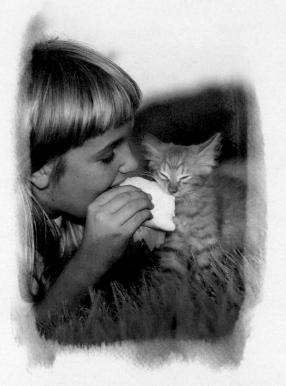

© Norvia Behling

22 *and your crayons*

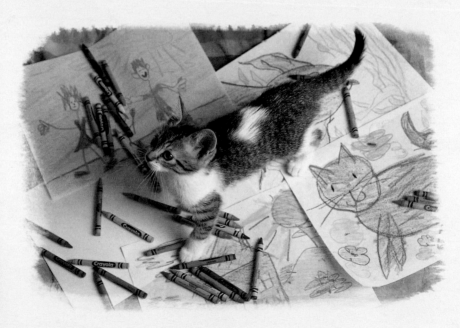

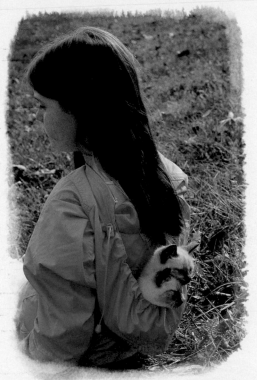

24 Dream catchers

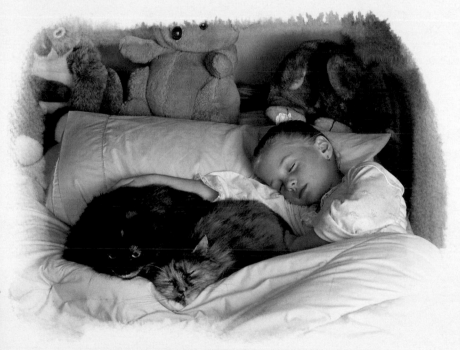

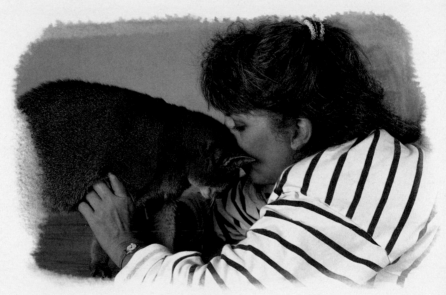

© Norvia Behling

26 *Gossip*

Someone to brave the slopes with

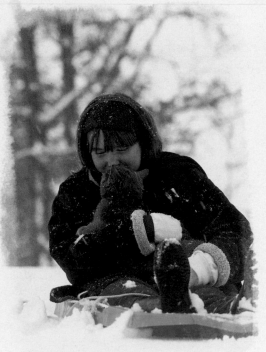

28 *Portable heater*

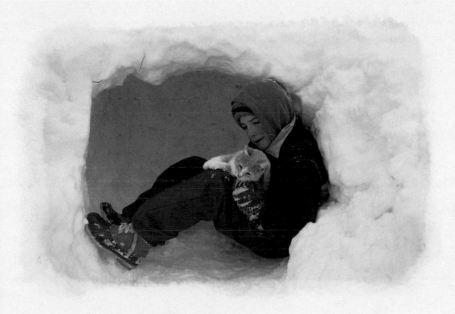

29 *Doll*

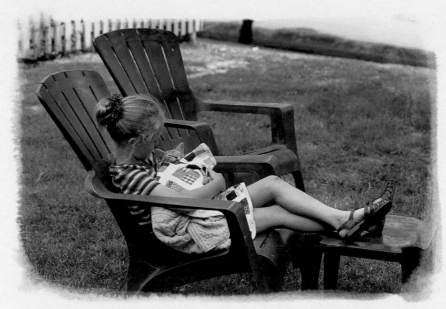

© Bonnie Nance

30 *First mate*

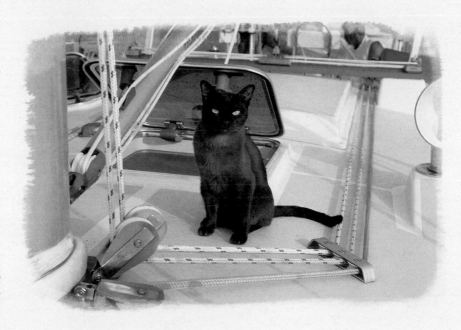

31 *Someone to grow up with . . .*

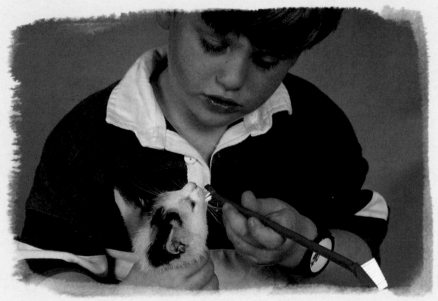

© Norvia Bahling

32 *. . . and grow old with*

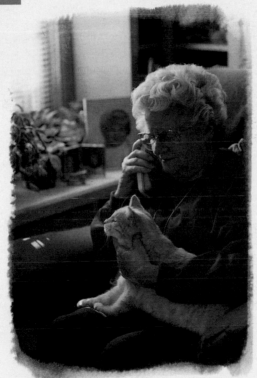

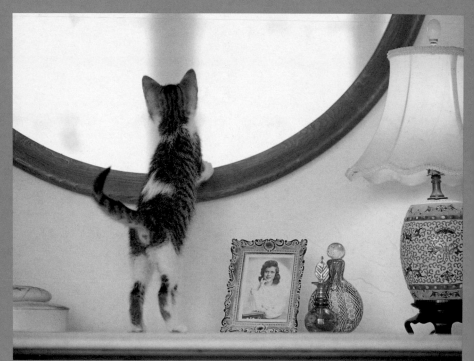

. . . helping around the house

33 *Bookend*

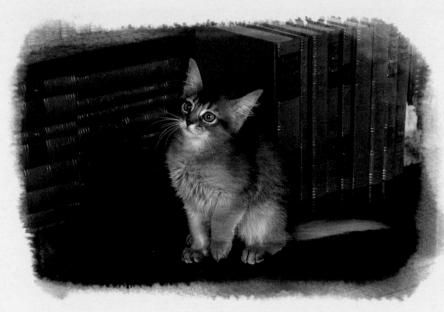

© Ron Kimball Studios

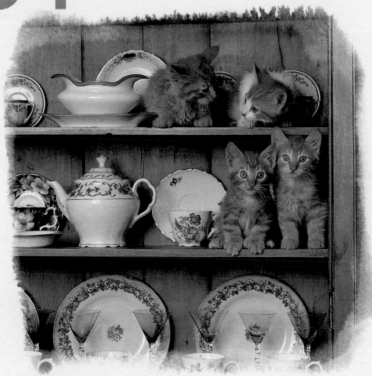

35 *Bakery supervisor*

© Norvia Behling

36 *Sous-chef*

37

Help fold the laundry . . .

. . . or carve a jack-o-lantern

© Nancy McCallum

39 Refinish your furniture

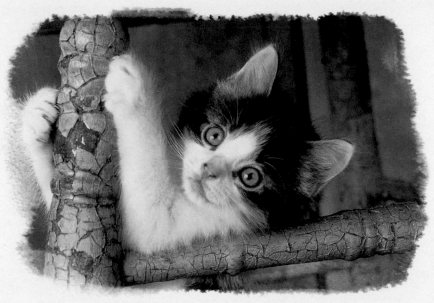

© Norvia Behling

40 *Give your boots an authentic,*
well-worn look

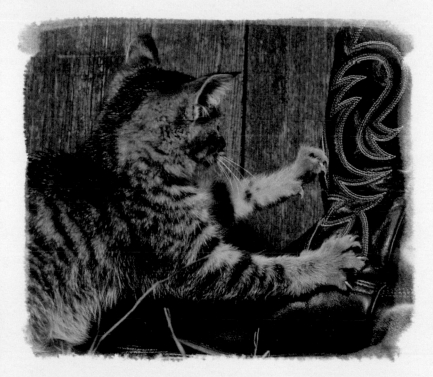

Window treatment

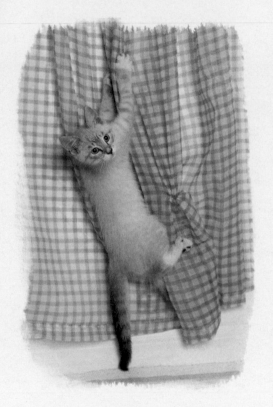

© Norvia Behling

42 *Fabric softener*

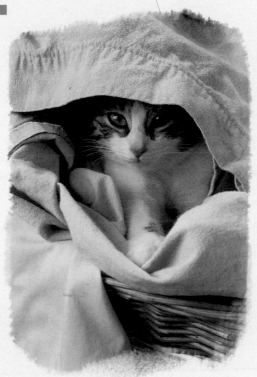

Plant fertilizer

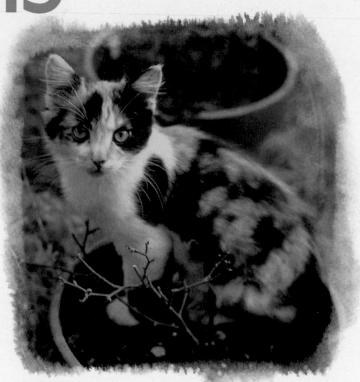

44 *Private eye*

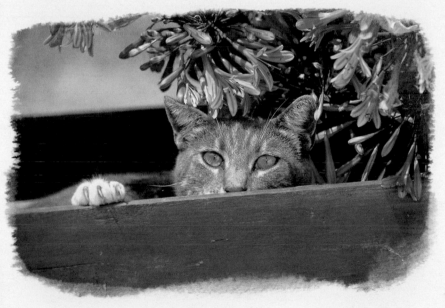

Help with planting

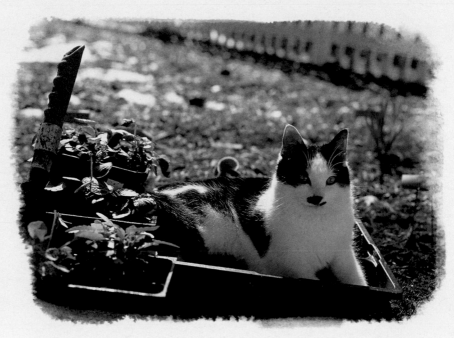

46 Scare off pests

47 Gatekeeper

© Ron Kimball Studios

Solar heat cell

© Nervia Behling

49 *Christmas tree trimmer*

50 *Christmas ornament*

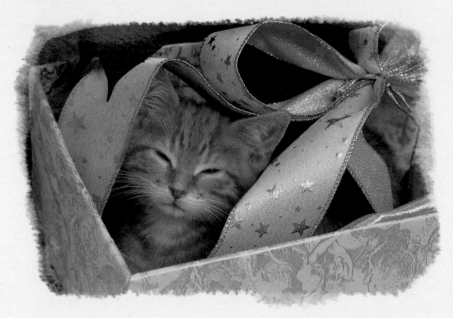

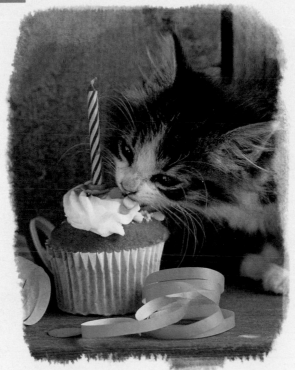

© Sharon Eide / Elizabeth Flynn

53 *Handyman's helper*

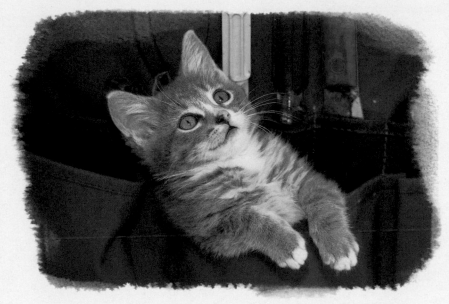

© Sharon Eide / Elizabeth Flynn

54 *Roto-Rooter*

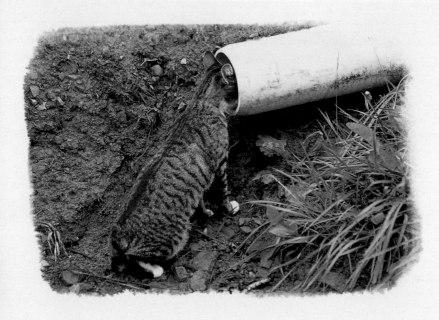

© Bonnie Nance

55 Child nutrition consultants

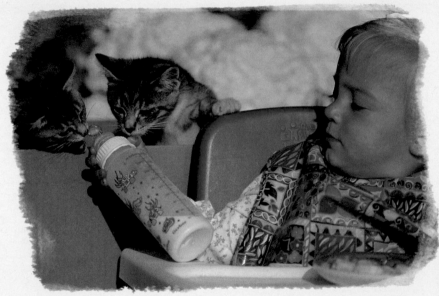

© Richard Hamilton Smith

56 *Troublemaker*

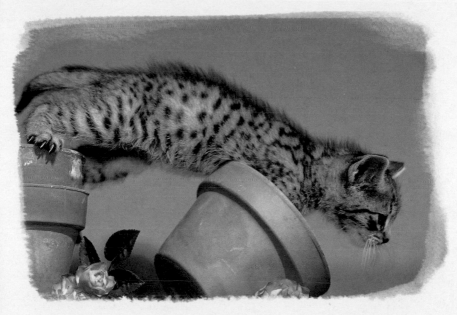

© Sharon Eide / Elizabeth Flynn

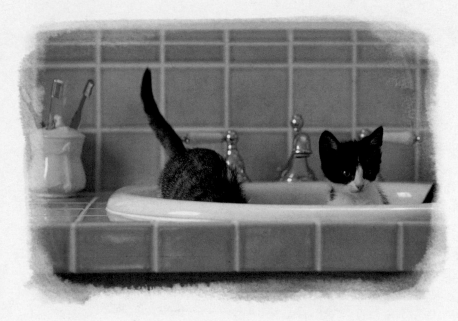

58 Butlers

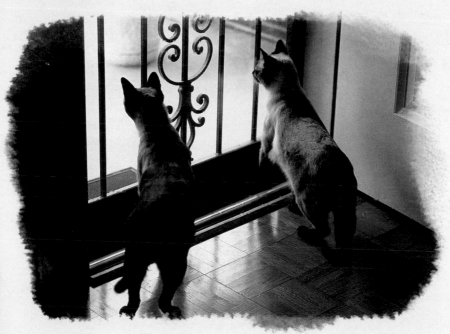

© Bonnie Nance

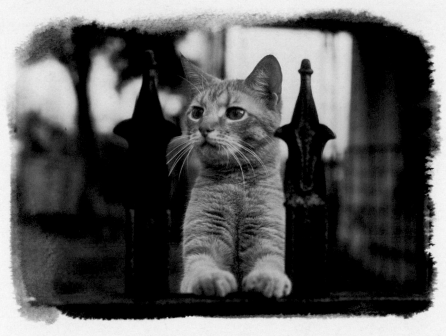

60 Groundskeeper

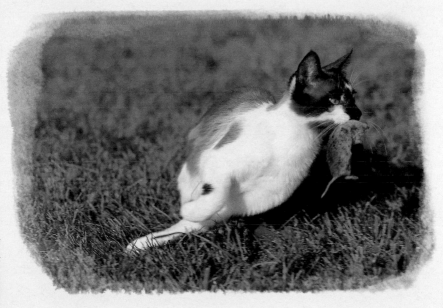

Seat warmers

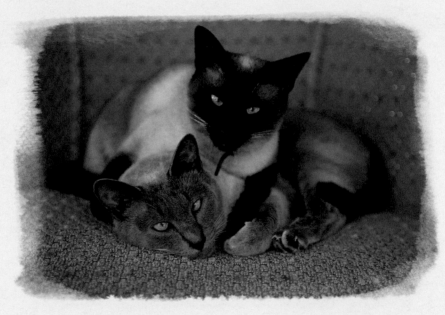

62 *Pillow*

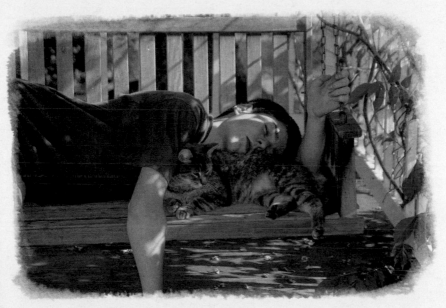

Odor eaters

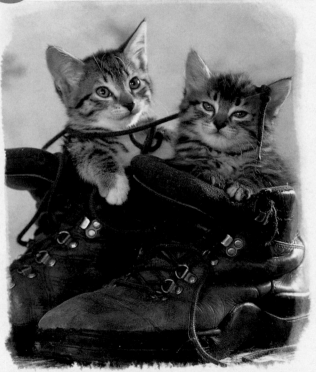

© Alan & Sandy Carey

Fur hat

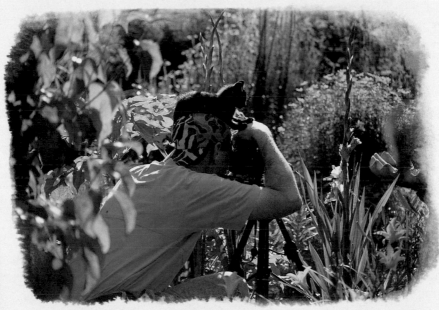

65 Six-pack

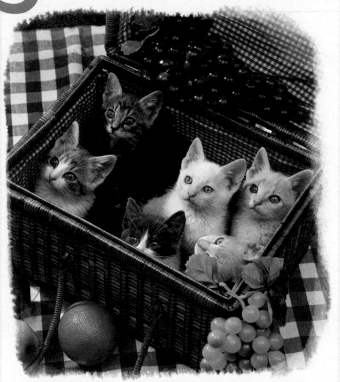

© Ron Kimball Studios

66 *Lucky charm*

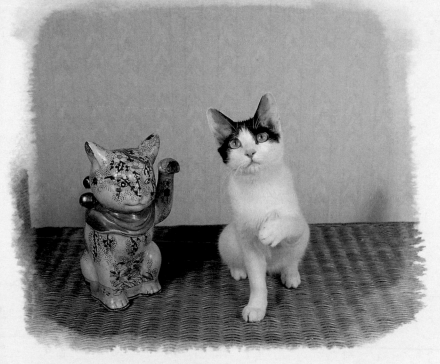

Email correspondent

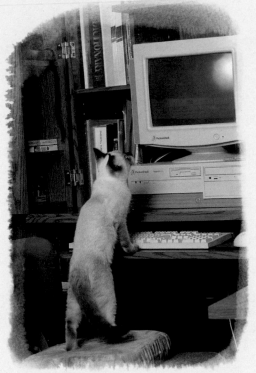

68 Desk accessory

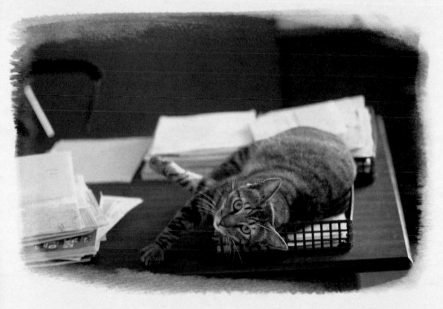

© Ron Kimball Studios

69 Centerpiece

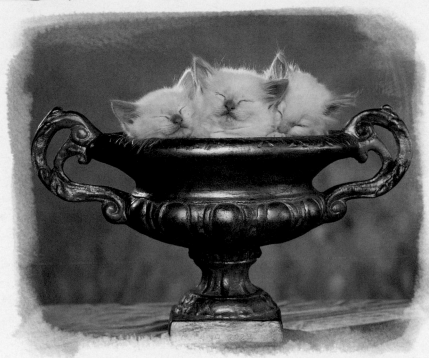

70 Bookmark

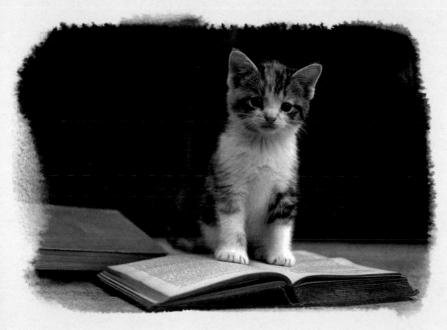

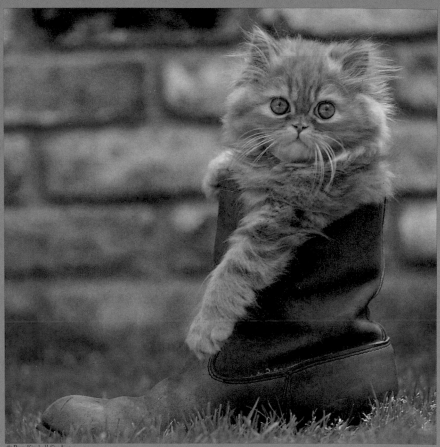

© Ron Kimball Studios

and filling
special
roles

Choose a fine wine

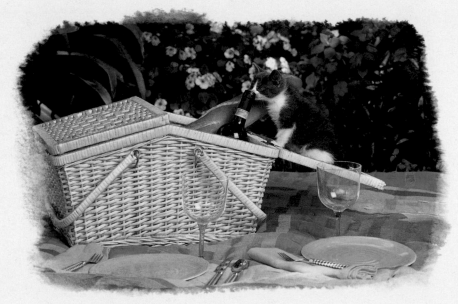

© PlaceStock Photo.com

72

Pick up chicks

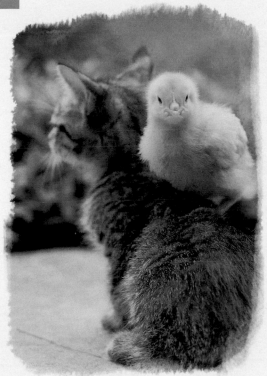

73 Street performer

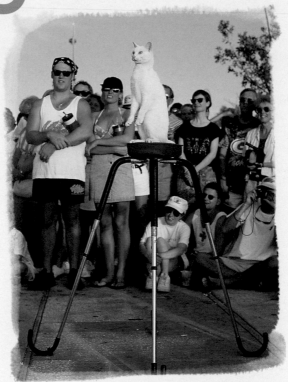

© Sally Weigand

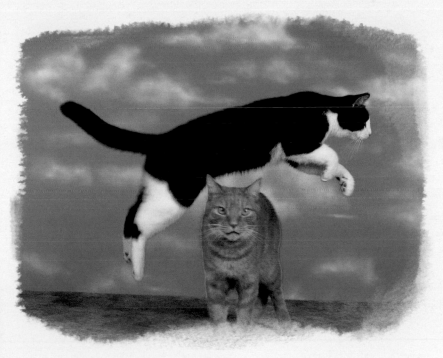

High-wire walker

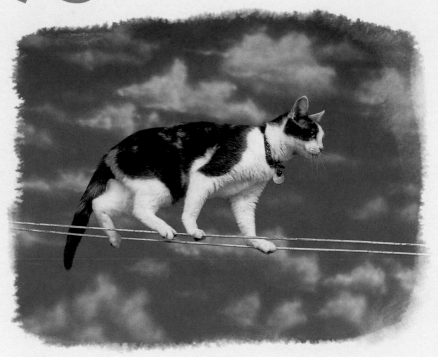

76 Acrobat

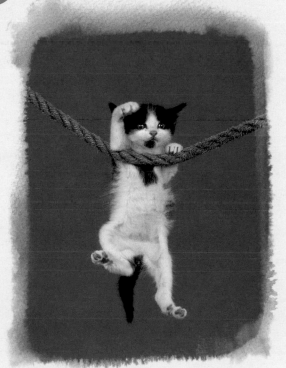

77 *Snow angel*

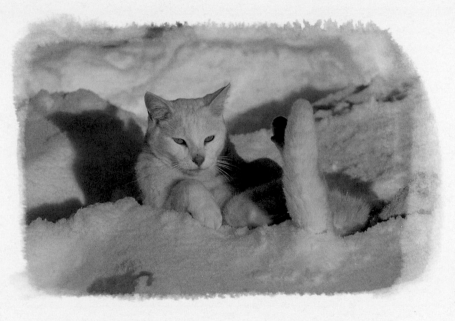

78 *Prima donna*

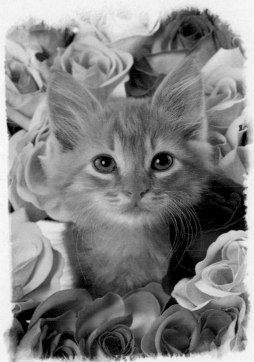

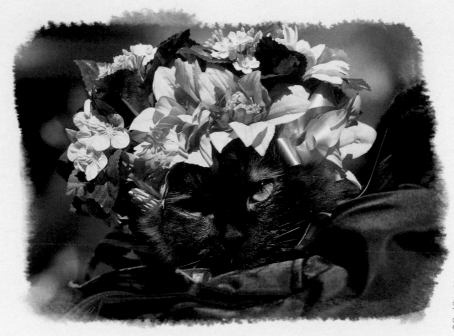

80 *Femme fatale*

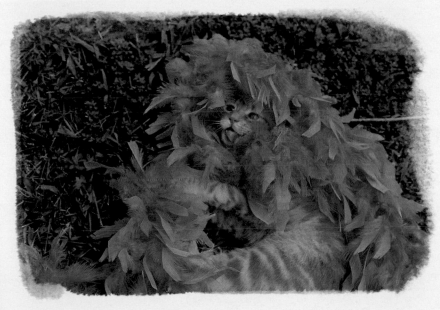

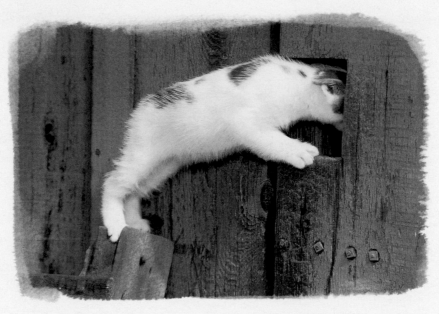

© Sharon Eide / Elizabeth Flynn

82 Car alarm

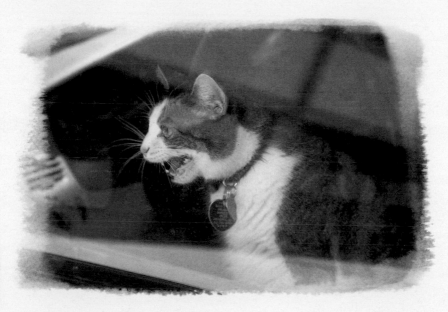

Bumper sticker

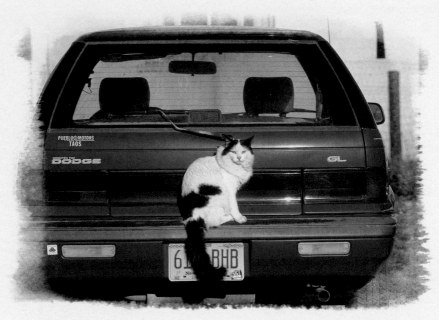

© Carol Simowitz

84 *Hood ornament*

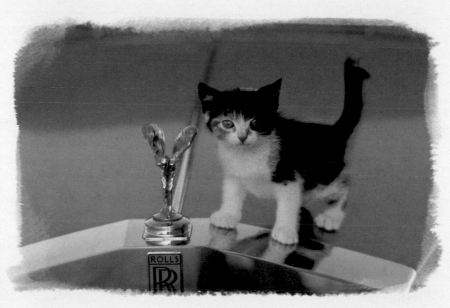

85 *Pandora's box*

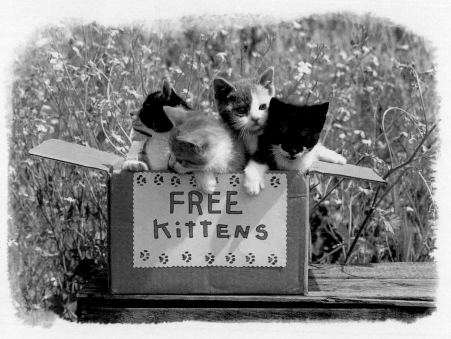

© Sharon Eide / Elizabeth Flynn

87 *Furball*

88 Goofball

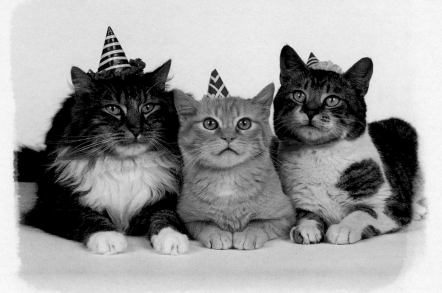

90 *Clowns*

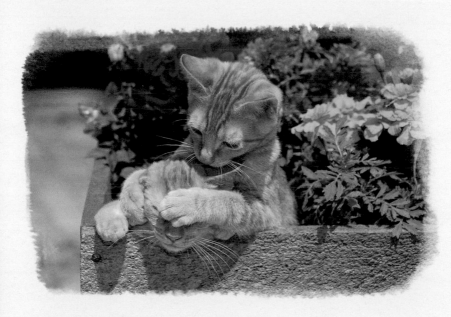

Teddy bear

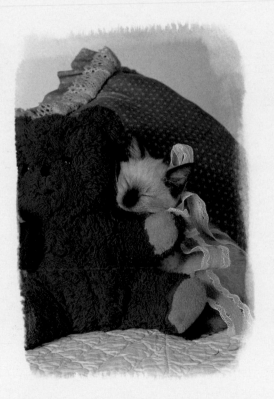

92 Dog

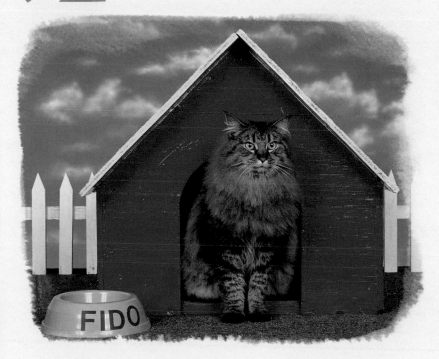

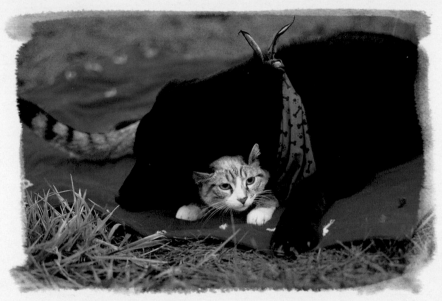

© Bonnie Nance

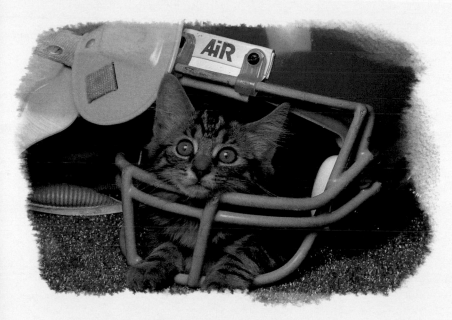

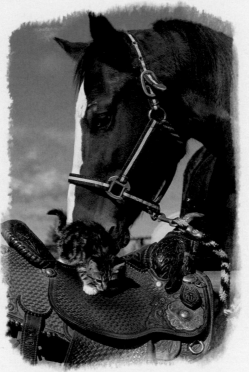

96 Poet

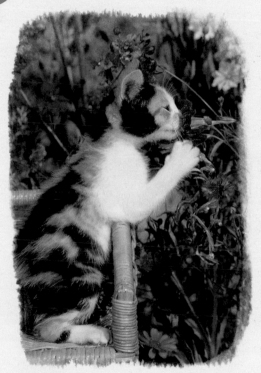

97 *Pianist*

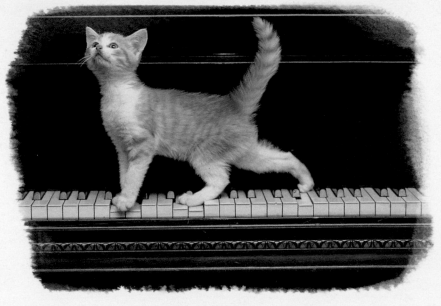

98 *Librarians*

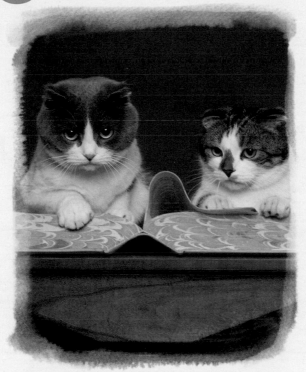

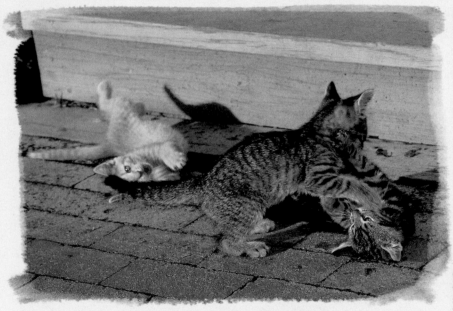

© Cheryl A. Ertelt

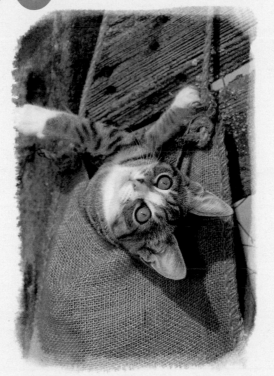

Best friend

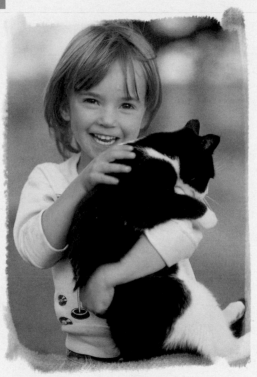